Winifred Nicholson

Music of Colour

KETTLE'S YARD, UNIVERSITY OF CAMBRIDGE

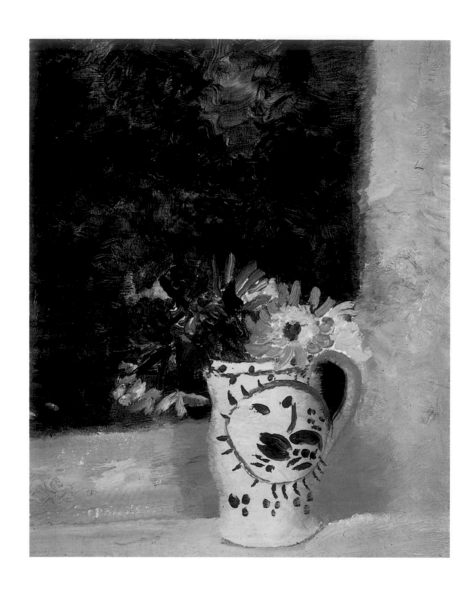

Flowers, c.1960
Oil on canvas, 490 x 390 mm
courtesy the Mistress and Fellows, Girton College, Cambridge

frontispiece: Winifred Nicholson, 1960s. Photograph Pamela Chandler
over page: Winifred Nicholson, letter to Jim Ede, 1967

CONTENTS

49 Elm Park
Gardens.
S.W.
10.

Dear Tim -
Thank you for coming up
and for getting that saxifrage
picture - I was so glad
that you like it enough to
want it for your new
gallery -
About the dressing table.

PREFACE

Jim Ede described himself as a friend of artists, and his friendship with Winifred Nicholson was one of his longest, spanning over fifty years. During that time he acquired nine works for the collection at Kettle's Yard. The first work Jim bought was 'Seascape' (1926), which Winifred painted when Jim and Helen Ede and Winifred and Ben Nicholson were on a joint family holiday in Northumberland. The delicate pastel and watercolour on paper, 'White Saxifrage' (1967), was the last piece he bought, from an exhibition of Winifred's work in London in 1972. This was just before the Edes left Kettle's Yard to live in Edinburgh. Over the years, Jim was able to supplement his own purchases with a number of gifts from the collection of Helen Sutherland, who was a mutual friend of both Winifred and Jim. A tenth work, painted during Winifred's last decade, was donated to Kettle's Yard in 2001. Today, this group of works constitutes the largest number of works by Winifred Nicholson in a public collection. Seven of these are permanently displayed in the Kettle's Yard House.

Winifred Nicholson is perhaps best known for her gentle paintings of flowers, still lives and landscapes. Less well known is her involvement in the European avant-garde, her membership of the Seven and Five Society and Circle, or her friendships with artists such as Piet Mondrian, who trusted her understanding of colour so much he asked her to source paint for him in England. Winifred was the first person in Britain to buy a Mondrian painting; she also owned works by Giacometti, Hélion and other artists she knew in Paris. Winifred developed radical theories on colour, and she was a gifted and articulate writer.

In many ways, Winifred Nicholson is the best person to talk about her work. Here, we have brought together some of her writing, in the form of essays and letters, covering topics from colour and light to art and life. Alongside these, Jim's words on Winifred offer intimate insight into the ideas, experiences and passions they shared. Both the poet Kathleen Raine and the collector Helen Sutherland

were close friends, and their comments illuminate the experience of daily life with Winifred. In her introduction, Elizabeth Fisher explores the relationship between the artist and Kettle's Yard. Drawing on materials held in the archives at Kettle's Yard and by the Trustees of Winifred Nicholson, including previously unpublished excerpts from the correspondence between Winifred and Jim, this publication offers new insight into the artist behind the paintings, and for the first time, reveals the part she plays at Kettle's Yard.

This updated book was originally published in 2012 to complement a new exhibition which looked afresh at the works held in the Kettle's Yard and Girton College collections. We are grateful to Jovan Nicholson, the Trustees of Winifred Nicholson and to Girton College, Cambridge for their generous assistance with both the exhibition and this publication. At Kettle's Yard Elizabeth Fisher brought together both projects with expertise and insight, curating the exhibition and editing this publication. She was ably supported in this work by Paul Allitt, Guy Haywood, Sarah Campbell and Rosie O'Donovan. Anna Ferrari and Claire Daunton provided invaluable help with archival materials.

As a department of the University of Cambridge, enquiry and experiment are at the heart of Kettle's Yard. We pursue and promote new research through our exhibitions and publications. We welcome scholars from across the UK and internationally. Through our visual arts, music and public engagement programmes, we reach over 100,000 visitors a year. None of this would be possible without the vital support of our funders and regular donors. Our sincere thanks are due to Arts Council England, Research England, and the Patrons and Friends of Kettle's Yard.

Andrew Nairne, Director

December 2021

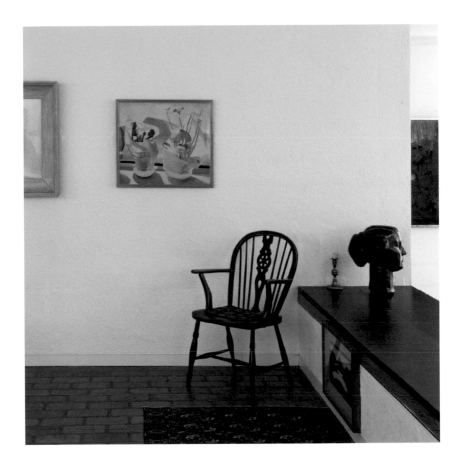

Cyclamen and Primula hangs in the 1970s extension of Kettle's Yard House next to **Seascape** and **Sam Graves**. Also shown: **Mountain Lake** (1943) by L.S. Lowry and **Head of Mlle Borne** (1914) by Henri Gaudier-Brzeska.

*"All my spare time…I spend trying to delve further, to find more.
When one is young one is satisfied with a flower petal or a
sparkle. Now I want more – of the rainbow scale of the flower
and the reason and the travel of the sparkle, and most of all a
long quiet time of peace and uninterrupted thought…"*

Winifred Nicholson, letter to Jim Ede, c.1940

INTRODUCTION

Winifred Nicholson (1893-1981) is one of the most important and best loved artists in the Kettle's Yard collection. Winifred met H.S. (Jim) Ede in 1924: she and her husband Ben Nicholson were relatively new on the London art scene, and establishing their reputations; Jim and his wife Helen were living in Hampstead and enjoyed hosting the bright young talents of the age.

Winifred made a great impression on Jim; he described her as "a leader – not only in a transformed style of painting – but in life itself." Winifred's influence is felt in the ideas that underpin Jim's vision for Kettle's Yard as "a continuing way of life." In the 1970 guide to Kettle's Yard, he wrote, "Winifred Nicholson taught me much about the fusing of art and daily living."

Jim's introduction to 'A Way of Life' begins, "The forming of Kettle's Yard began, I suppose, by my meeting with Ben and Winifred Nicholson in 1924 or thereabouts, when I was an assistant at the Tate Gallery." Jim had taken up a curatorial post at the Tate Gallery in 1922, and quickly developed a passion for contemporary British and European art. "It wasn't until I was nearly thirty that the Nicholsons opened a door into contemporary art and I rushed headlong into the arms of Picasso, Brancusi and Braque…" he wrote. Jim was drawn to a new kind of painting that eschewed stylistic conceits in favour of direct experience, and sought out an underlying spirituality in modern art. In the preface to a catalogue for an exhibition of the work of Ben Nicholson, Winifred Nicholson and William Staite Murray at the Lefevre Gallery, London in 1928, he wrote, "Winifred Nicholson comes closer to the physical; a sensuous love of life's intimacy, but treated with a vitality and a sparkle which makes her painting companionable and universal." Jim Ede shared the sensibility of his artist friends, and particularly that of Winifred. He embraced the way they responded to the world around them and strove to express that engagement as a way of life at Kettle's Yard.

Kettle's Yard is now widely recognised as a masterclass in curating; it rejects both the traditional displays of museums and the austerity of the 'white cube' in favour of a modest domestic space. This is art as a natural part of life, taking its place alongside "stray objects, stones, glass…in light and in space…used to make

manifest the underlying stability which more and more we need to recognise if we are not to be swamped by all that is so rapidly opening up before us."

For Jim, Kettle's Yard was a way of life in the same way painting was for Winifred. The poet Kathleen Raine wrote: "Winifred's painting grew out of her life with complete naturalness and simplicity. The day's painting was a kind of fragrance breathed by that day and no other, its imaginative essence, its heart. Each painting has its special mood and atmosphere, some joyous and full of light, some thoughtful and autumnal, others wild and lonely as winter; but all are alike in saying, like a character in Virginia Woolf's 'To the Lighthouse', 'Time stand still now! Because each day's here and now is so fully present, it lives on.'" ('The Unregarded Happy Texture of Life', 1984)

The play of natural light is one of the first things you notice at Kettle's Yard. Jim arranged rooms according to the way the light came in, through windows or skylights, positioning mirrors where they could reflect light effects around a space. Various glass objects, lenses and polished or reflective surfaces around the house alter the quality and direction of light as it hits them. I was once told a story about some friends who had been invited for dinner with Jim and Helen at Kettle's Yard. When they arrived on the designated evening, the house was dark and it seemed as if no-one was home. The dinner guests thought perhaps they'd got the wrong date. As they were about to leave, Jim opened the door and exclaimed "Come in! Come in! We don't turn the lights on because the light is so exquisite at this time of day!" I am reminded of Winifred's many paintings that depict light coming in through a window. Her description of a pot of lily-of-the-valley on a windowsill captures the intensity and delight with which she painted this view: "the tissue paper held the secret of the universe…sunlight on leaves, and sunlight shining transparent through lens and through the mystery of tissue paper." Winifred travelled extensively to paint, fascinated by the myriad qualities of light in places from Greece to Scotland, where she wrote "the beams fall slantwise, and shine through things instead of directly onto them as in India and Italy." She painted flowers because she said they "create colours out of the light of the sun." In her home, she built windows and also used mirrors to bring light into and around the interior spaces. Later in life, she used prisms to unlock the spectrum of perceived colour.

Jim created Kettle's Yard as "a refuge of peace and order...where an informality might infuse an underlying formality." And in 'I Like to Have a Picture in My Room' (1954), Winifred wrote, "In the ebb and flow of the outer world, I must have a place where the harmony of space is giving its verdict." Her aesthetic vision, like Jim's, was imbued with a sense of the spiritual, a connectedness to nature, and universal order.

The realm of the domestic, and the relationship between inside and outside, played a key role for both of them. Jim made his home his art; while the interior is balanced and stimulating, its relationship to the outside world is carefully choreographed, from the distant sight of Northampton Street interrupted by plants and various glass floats and other lens-like objects, to the view of St Peter's church, framed by cherry blossom he loved in Spring. Winifred made paintings that repeatedly position the viewer inside with her, looking out from a homely interior space onto an open landscape, with objects, often flowers, catching the eye and the light inbetween. In a work like 'Cyclamen and Primula', the distant mountains merge with the shapes and shadows made by the tissue in the immediate foreground, described by Winifred in blues and whites. The suggestion of the window frame marks a threshold, but her handling of the composition insists on a fluid connection between fore- and background. The flowers, the mountains, the space of the viewer and the spectacular natural scenery are tied tightly together pictorially and metaphorically.

Jim later wrote about Winifred: "The formal quality of Winifred Nicholson's work, for all its seeming informality and simplicity, is very powerful, highly organised. Her flowers which seem so flower-like, and I know of no-one who approaches so closely to the pure clarity of flowers themselves, are profoundly characteristic of the strength of mind and character which has received and responded to the flower life; making from this life a life of its own, a massive simplicity which is yet so delicate, so poised, so true."

There were, and still are, always fresh flowers at Kettle's Yard: usually simple cottage flowers picked from the garden and arranged in jam jars or glass vases around the house. From what Jim has written, it is hard not to see these flowers through Winifred's eyes, as containers of light and colour, and expressions of the underlying order they both sought in the world around them.

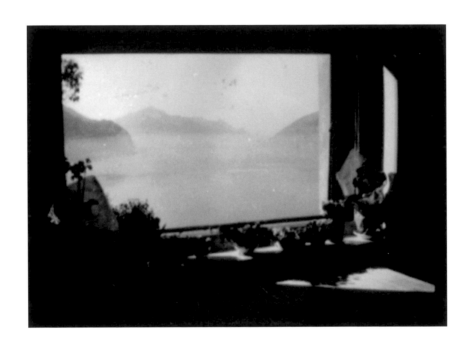

View through window at Villa Capriccio –
Lake Lugano in background, and flowers in tissue paper on windowsill c.1922-3.

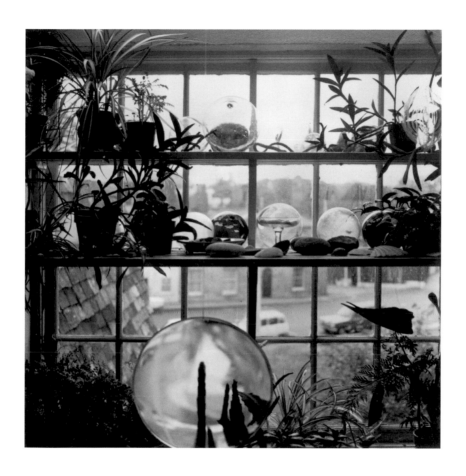

View through window in Kettle's Yard House
from 'A Way of Life'.

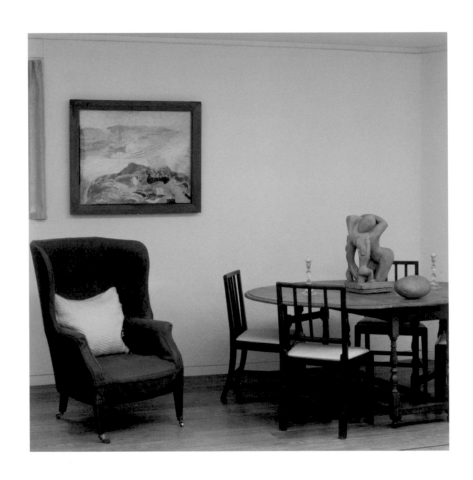

Seascape with Two Boats (1932) in Kettle's Yard House.
On table: Caritas (1914) by Henri Gaudier-Brzeska.

Jim was a friend and collector of Winifred's work over fifty years. He valued her opinions and consulted her on articles he wrote about both Ben Nicholson and Christopher Wood, and they continued to correspond after the Edes left Kettle's Yard and moved to Edinburgh in 1973. In 1975 Winifred gave Jim a small pot by William Staite Murray and an early 19th century English Staffordshire mug; both found a place at Kettle's Yard. Like many of the objects in the House, Jim offered no explanation of their presence or relationships with other things. It is almost as if their connections are too natural to need description, their presence at Kettle's Yard almost inevitable. This is how it is with Winifred's paintings.

A radical thinker, Winifred came from a family of liberal and pioneering women who have their own connections with Cambridge. Girton College's first library, the Stanley Library, was established in 1884 with a donation from Lady Stanley of Alderley (Winifred's great-grandmother). Girton was one of the first colleges for women established at Cambridge, and the college now owns two works by Winifred Nicholson. Lady Stanley was a keen proponent of education for women. Her daughter, Rosalind Howard (Winifred's grandmother), was involved in several causes including the women's suffrage movement. Rosalind Howard also saw the importance of education. She invited three Balliol scholars to stay with them; two married her daughters, one of whom, Charles Roberts, became Winifred's father. Winifred's sister was one of the first women to study agricultural science at Cambridge.

Over the last 40 years there have been three solo exhibitions of Winifred Nicholson's work at Kettle's Yard: the first was organised by Jim in 1972, then the Tate Gallery retrospective came to Kettle's Yard in 1988, and in 2001 Kettle's Yard organised a survey of her work which toured nationally, and drew record visitor numbers at Kettle's Yard. When she first began exhibiting in the 1920s, Winifred enjoyed enormous success and recognition. In 1927, the Observer critic P.C. Konody wrote, "She probably has no equal among modern British painters as a colourist of the most exquisite refinement." The latest display and publication offer a snapshot of the life and work of this remarkable woman, whose enduring popular appeal is testament to the understated confidence, intelligence and sensitivity with which she embraced the world around us.

Elizabeth Fisher, Curator

Sam Graves and **Seascape** hang in the 1970s extension of Kettle's Yard House next to
Cyclamen and Primula (not shown).
On chest of drawers: **Three Monkeys** (1914) by Henri Gaudier-Brzeska.

H.S. (Jim) Ede on Winifred Nicholson

In the mid-1920s when I first came to know her, Winifred Nicholson was a leader – not only in a transformed style of painting – but in life itself. She and Ben Nicholson transformed everything – wooden boxes became stylish chairs, ugly stoves were desirable objects and butter-muslin came into fashion.

Winifred Nicholson is essentially a woman painter and she stands, I think, foremost amongst those of today. She does not endeavor to hide her sex in her work, she is proud of it and brings to painting a woman's attitude which no more competes with a masculine one than did Emily Brontë's. They are both inherently feminine. It is because she is a woman that she has so deep a knowledge of growth – the life and nature of plants and of landscape. She has a sympathy for these things born of understanding. She paints a pot of flowers and in it you feel the laws of universal birth – it isn't just these flowers growing – it is the whole life of nature; a field or wood painted by her has not the fixed aspect of a field or wood at a given moment, but has the sense of continual change.

There is no question of a photographic rendering, it would matter very little to Winifred Nicholson whether the sun shone or whether it did not – what matters to her is that the country should be alive with growth, should have the power of change. To her observant eye this change is so varied and so rapid that 'finish' as it is understood in pictures is an impossibility. There is scarcely time for the rapidest of notes, but these notes touch so closely the heart of the essential and are so well related to each other that they convey the vital beauty of the thing depicted. She obtains a great freshness in her painting, and for colour, I know of no one who interprets so truthfully the pure clarity of flowers themselves. There is about it all an ease and simplicity, an apparent effortlessness, inevitable as the moving of clouds in a blue sky; and this is because her work is a thing felt before it is seen. If effort there was to produce her painting it passed in the feeling of it, and to us the recipients or onlookers it flows with a swift surety.

Winifred Nicholson is a colourist. Colour has always been her chief interest. She wrote "as a child I painted rainbows, then I painted the prismatic colours in the mother of pearl of shells and was told by my art teachers that I was 'seeing

colours' where there were none. I painted sunlight coming through chestnut leaves, setting a leaf aglow like a luminous magic lantern of emerald light. I was told that my green was crude. I painted things up against windows so that the sunlight could be seen coming through them, all luminous; contrasted with sunlight striking on them, all shine. I never painted in a room that did not face the sun, nor when the sun was not shining."

The formal quality of Winifred Nicholson's work, for all its seeming informality and simplicity, is very powerful, highly organised. Her flowers which seem so flower-like, and are profoundly characteristic of the strength of mind and character which has received and responded to the flower life; making from this life a life of its own, a massive simplicity which is yet so delicate, so poised, so true.

Her earliest work at Kettle's Yard was painted in 1923. It is 'Flowers in Paper'. It has not only the local life of these particular objects, flower, pot, plant, paper; it has the sense of air and space, of birds in the air, of sounds and warmth, of domestic life in its essential simplicity; and of the joy of opening windows; not only material ones, into a bright morning. Much more beside; the poetry of life, but seasoned with a strong robust element of common sense, the touch of reality; that actual world which is so necessary to such an artist as Winifred Nicholson in order to call out her power and response; a response which is to produce a work of her own in the likeness of the world that touches her.

Her large 'Landscape' has always been to me a great world of beauty, it has an uplift of light, everything is growing and spreading from the bottom of the painting to the top, and all is infused by the clean vigour of early morning. There is a feeling of universal birth, and this is characteristic of Winifred Nicholson's work. It is not the solitary life of the local object that she sees, but that of its species. Her painting comes close to the physical, a sensuous love of life's intimacy treated with a penetration and a sparkle which makes her painting companionable and universal.

Excerpts taken from unpublished early drafts of 'A Way of Life.'

Road Along the Roman Wall, hanging in the extension of Kettle's Yard House.
Also shown: **Caritas** (1914) by Henri Gaudier-Brzeska; **The Black City I** (New York) (1949) by William Congdon; **Sanctuary Lamp** (1955) by David Peace; **Three Personages** (1965) by Barbara Hepworth.

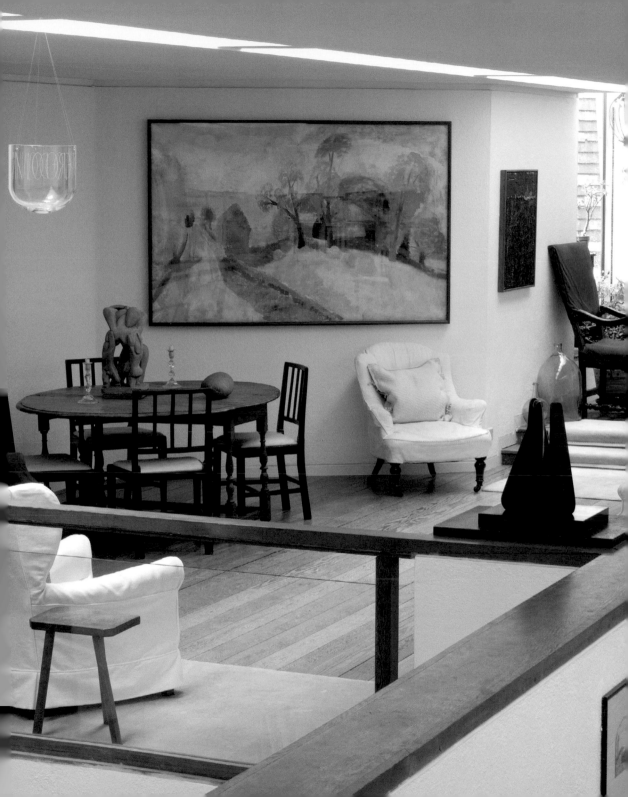

Winifred Nicholson

works in the
Kettle's Yard collection

"Winifred Nicholson's 'Flowers and Paper',
c. 1923, [Cyclamen and Primula] hangs in the
Extension with two other works by her.
I had always wanted this particular painting which
I think must have been in an early exhibition, or
seen from a photograph; and then years later a
Cambridge dealer had recognised it, so dirty as to
be hardly visible, so he got it 'for nothing', cleaned
it a little, and let me have it for what I could
manage. Even then it needed a good scrubbing,
and now is this delight of sunlit shadows and
insubstantial substance."

H.S. (Jim) Ede, 'A Way of Life'

Cyclamen and Primula, c. 1923
Oil on board, 500 x 550 mm
Kettle's Yard

Cyclamen and Primula was painted by Winifred Nicholson in Lugano,
Switzerland. In 1921 she and her husband Ben bought the Villa Capriccio,
near Castagnola in the Ticino. Two years later they purchased Banks Head,
a farmhouse in Cumberland which remained Winifred's home for the rest
of her life. Between 1920 and 1923 the Nicholsons spent the winters in
Switzerland and the summers in England. This pattern suited Winifred who
continued to spend a significant part of each year travelling abroad to paint.

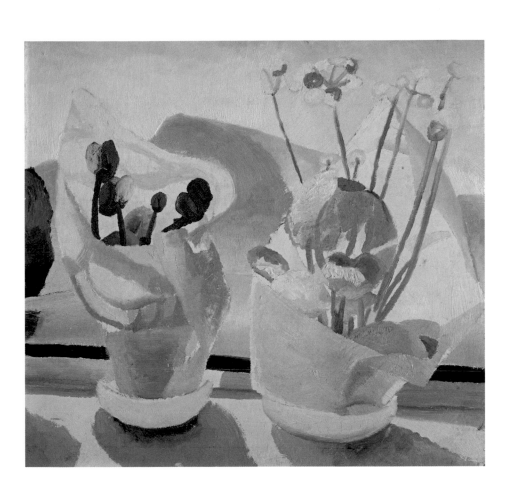

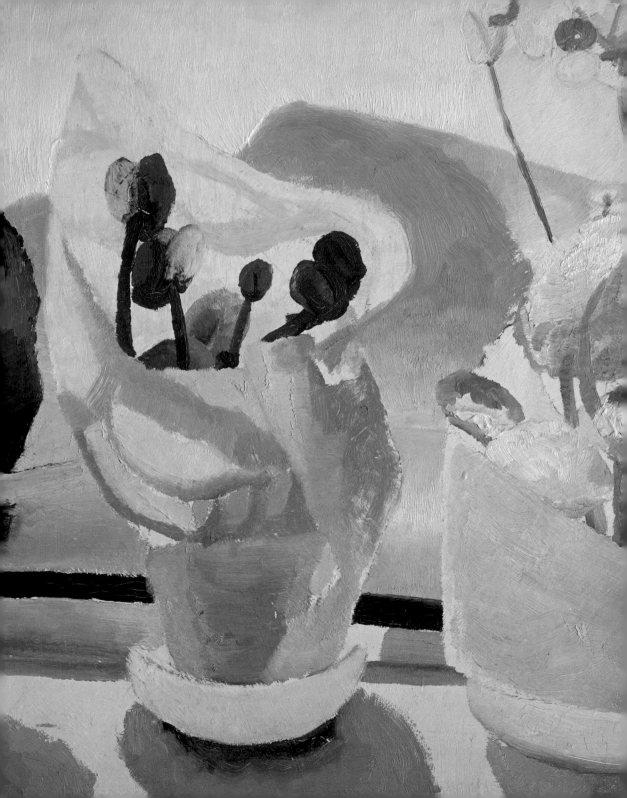

"How many winters were there? I do not remember – but that last one our painting came to a flowering point. It had hatched – Ben had given me a pot of lilies of the valley – Mugetti – in a tissue paper wrapper – this I stood on the window sill – behind was azure blue, Mountain, Lake, Sky, all there – and the tissue paper wrapper held the secret of the universe. That picture painted itself, and after that the same theme painted itself on that window sill, in cyclamen, primula, or cineraria – sunlight on leaves, and sunlight shining transparent through lens and through the mystery of tissue paper.

I have often wished for another painting spell like that, but never had one."

Winifred Nicholson (c.1969) 'Unknown Colour: Paintings, Letters, Writings by Winifred Nicholson'

"For a long time the big Winifred Nicholson
landscape hung just outside my office at the Tate
Gallery – I could not manage the (price) asked for
it, but Miss Sutherland could – and finally when
it came to Nicolete Grey she generously gave it to
Kettle's Yard."

H.S. (Jim) Ede, 'A Way of Life'

Road Along the Roman Wall, 1926
Oil on canvas, 1265 x 1895 mm
Kettle's Yard

This is one of many paintings made by Winifred Nicholson at Banks Head.
The view is of a nearby farm building along the road from her home.
Nicholson sought to capture the light and atmosphere of a particular place
and moment, so usually completed a painting in a single sitting.
The ambitious size of this painting reflects her interest in experiment and
testing the limits of her practice.

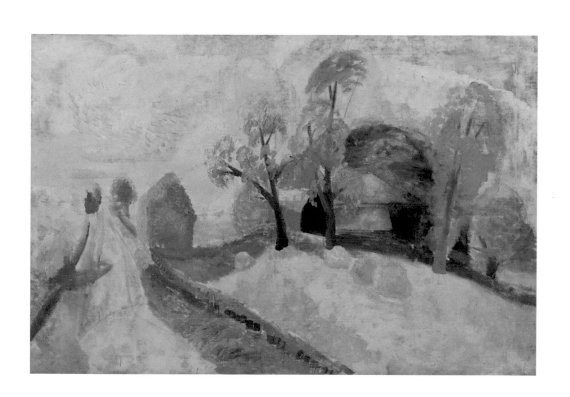

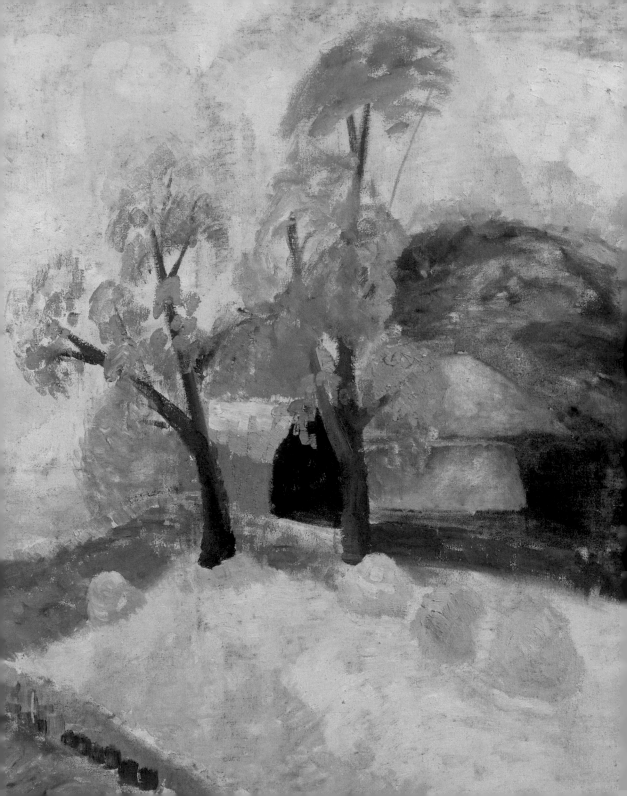

*"It's lovely here – I've been picking blackberries
all the morning, and mushrooms, the mushrooms
for old sake's sake, for they have the consistency
of very, very old people's cheeks. The blackberries
are luscious and shiny and sweet, and so many
of them, there are more than all the thrushes and
robins and squirrels and bramble jelly makers
and little weevils can possibly think of. There
is glittering sunshine and limpid rain in the sky,
the plaything of the wind, which rushes it about
and leaves it in the end in the grass, and shiny
amongst the sheep's scabious and cow dung. All
the wet earth smells so fragrant. The ferns are
turning tawny, and the hedges are sparse and
full of berries. The wind blows right through your
body. I don't want anything in the world – I just like
existing every minute, and watching things coming
and things going, and then coming again, like
storms and sunshine and then storms again. I don't
want anything at all for the simple reason that I
have everything, or rather, which is the same thing,
everything has me … "*

Winifred Nicholson, letter to Edith Jenkinson (student friend),
Banks Head, 1925

*"I so well remember her bringing back 'Seascape'
after her first morning on the sands beyond
Bamburgh. It was a windy morning and she had
difficulty in holding the wet oil from blowing against
her. I had never seen sea treated in this way; so
loose, so bold, so unconcerned with detail. She
seemed to have brought all the world up the steep
hill to the castle where we had spent the previous
night. That tremendous sky and the rich warmth
of sand; and where could she have been in that
overwhelming pulsation? As I write now in this book,
all that was 55 years ago, and the urgency of her
work still holds me. It lives now in Kettle's Yard."*

Jim Ede, 'A Way of Life'

"All English people like the sea."

*Winifred Nicholson, Introduction in
'Christopher Wood', Arts Council 1979*

Seascape (Sea and Sand), 1926
Oil on canvas, 490 x 590 mm
Kettle's Yard

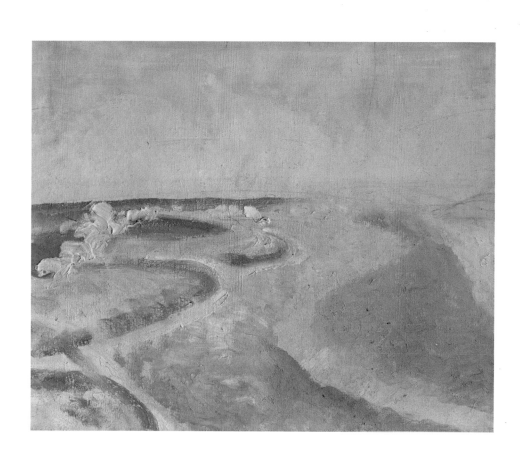

"I did so enjoy being painted and the joyous ardent way you did it. It is a lovely life, all that creative imaginative fervour and beauty and then Ben and the Babies and the household and the animals and the country people and the farms and your people and the way you still have room for friends and strangers and all who knock at your door and come in to the gentleness and understanding and generous love you give – It is most lovely and precious and refreshing ... I see now you never will come to an end with painting, either you or Ben – it really is a big world. Landscape, flowers, people – each a kind of discovery lifting up the other kind."

Helen Sutherland, letter to Winifred Nicholson c.1929

Sam Graves, c.1928
Oil on board, 530 x 610 mm
Kettle's Yard

Winifred Nicholson often painted the things around her – which included the landscapes she visited, the domestic environment and her family.
Sam Graves, born in 1924, was the youngest child of the poet Robert Graves and Nancy Nicholson (Winifred's sister-in-law).

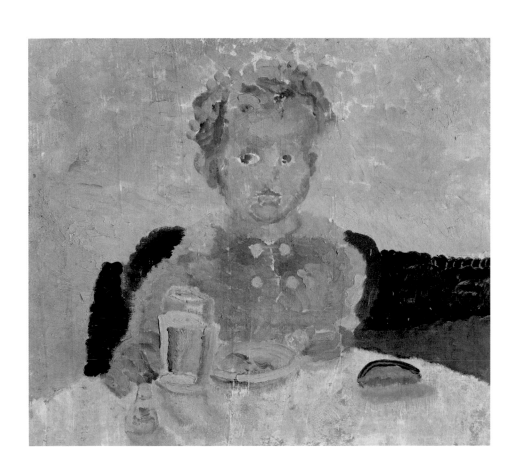

"how is The little as he sailed
is Boat yet i serpose you have
a pool with you near By
try it i do not think it ever
Been tried if he is like me
i was always for Boats
you must go out and Try it"

Alfred Wallis, letter to Ben Nicholson, 28 January 1929

Seascape with Two Boats, 1932
Oil on canvas, 680 x 870 mm
Kettle's Yard

Winifred Nicholson met Alfred Wallis when she and Ben Nicholson spent
a summer with their children in St Ives, Cornwall, in 1928. Of this trip, she
wrote: "I painted ... with keenest delight. My little boy (Jake, b. 1927) ran
with bare feet by the sea. When the winter set in we had to go. It was a
bitter wrench for me." Alfred Wallis gave the Nicholsons a toy boat he had
made, and in this painting Winifred depicts her eldest son, now aged 4 or 5,
playing with the boat in a rock pool.

 Winifred's way of working quickly was well suited to a busy and
demanding family life. Jake recalls that she planned paintings in her head,
sometimes the night before – very rarely indeed drawing any kind of
preparations on paper – and then went at them in a sustained burst of
concentrated effort. She painted directly onto canvas or board, over the
most minimal indication in pencil to suggest the location of features in the
composition. Quite deliberately, she would not always paint over these
skeletal lines, leaving them visible as here.

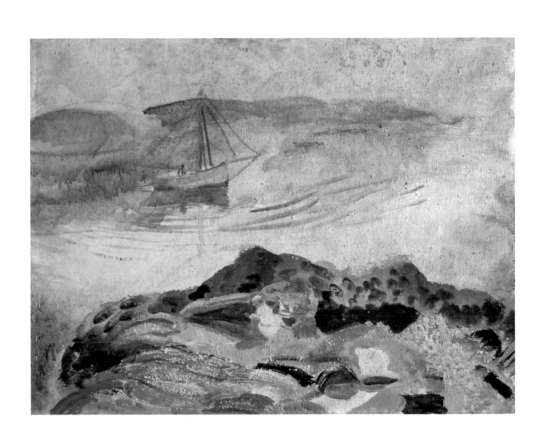

*"There is I always feel so much sky between the
eye that is the watcher and the distant hills or sea
... more sky in that air gulf than in the sky itself –
at least that is where I always paint the sky – in
between me and the horizon – the sky that is above
the horizon looks after itself. All painting is to me
painting of air and sky – that holds colours and
light – not pictures of objects."*

*Winifred Nicholson, on the envelope of a letter
to her daughter Kate, 30 August 1951*

Flodigarry Island, 1948
Oil on canvas, 615 x 615 mm
Kettle's Yard

Flodigarry is an island off the Isle of Skye, a place that Winifred loved.

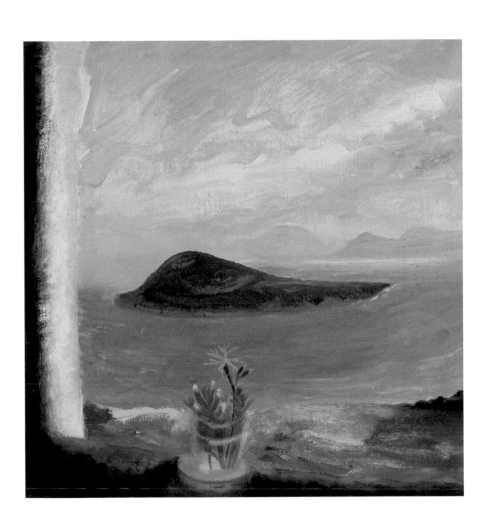

*"I like painting flowers – I have tried to paint
many things in many different ways, but my paint
brush always gives a tremor of pleasure when I
let it paint a flower – and I think I know why this
is so. Flowers mean different things to different
people – to some they are trophies to decorate their
dwellings (for this plastic flowers will do as well as
real ones) – to some they are buttonholes for their
conceit – to botanists they are species and tabulated
categories – to bees of course they are honey – to
me they are the secret of the cosmos."*

Winifred Nicholson, 'The Flowers Response', Spring 1969

Daffodils and Hyacinths, 1950-55
Oil on canvas, 585 x 485 mm
Kettle's Yard

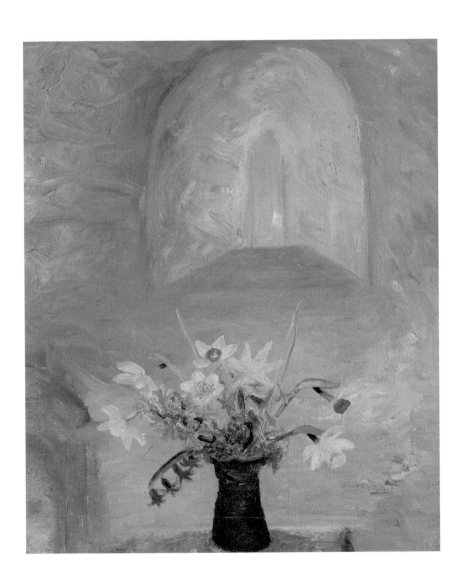

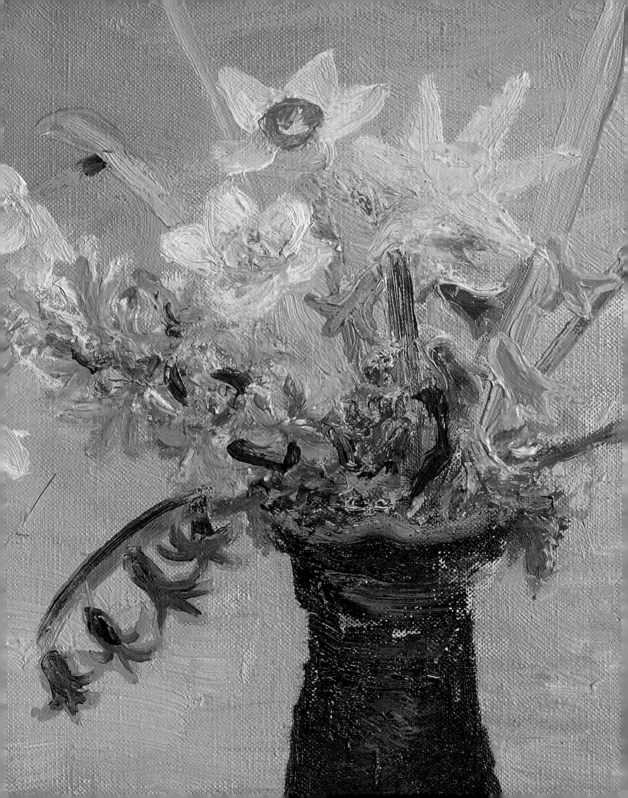

"Colour is seen in growing things, living the life of the rainbow curve, the sevenfold spectrum. Flowers create colours out of the light of the sun, refracted by the rainbow prism. So I paint flowers, but they are not botanical or photographic flowers. My paintings talk in colour and any of the shapes are there to express colour but not outline. The flowers are sparks of light, built of and thrown out into the air as rainbows are thrown, in an arc."

Winifred Nicholson, 'Three Kinds of Artist', 1974

"My pet lamb comes into play when I want to paint RED. The other day a flaming poppy. Vulgar, untrue, even brilliant. I call into play someone to resolve this, and make my poppy real – first orange, my next door neighbour, only makes more vulgarity – green, my opposite, makes my red tone down, neutralising its vitality. Of course I jump the gap of the unknown colour and call it magenta, a little, very little will make my vulgar red into a biting vicious luminosity which is what I want. I can see this colour when I look through a very powerful microscope at the petals of a flower, at the feather of a hummingbird. I can see this if I look at the colours used by the Persians or Matisse or anyone who uses colour as dynamite, as something that shatters blind dullness of vision."

Winifred Nicholson, letter to Professor Glen Schaefer, late 1970s

Fireside, 1956
Oil on canvas, 500 x 600 mm
Kettle's Yard

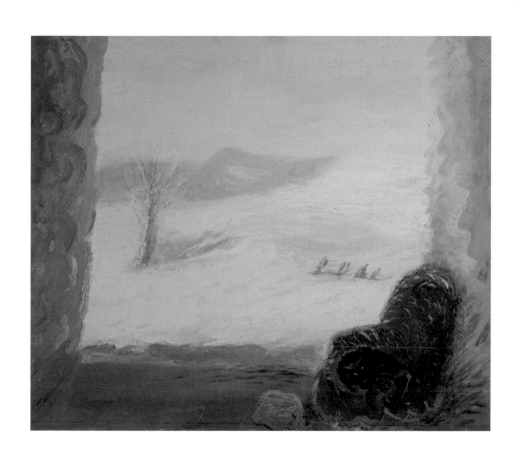

"Colour has nothing to do whatsoever with the passing of time.
There see the scarlet radiating from that tulip – it was eight
minutes ago in the sun. See that crimson flame, darting out of
the black lump of coal in your fireplace. Neither journey through
space, nor burial in the bowels of the earth, can alter the
brilliance of that colour which was in the sun a millennium ago –
or just eight minutes past...
"Sunlight, moonlight, candlelight, electric light, all change the
colour of an object – a human eye, a bird's eye, a bee's eye, a
butterfly's eye, all see the colour differently. So the local colour
of an object does not belong to the object. The colour that seems
to sit on it is subjective, fleeting, effervescent, and is as illusive
as magic."

Winifred Nicholson, 'Radiance in the Grass', first published 1978.

"Sometimes we discussed technical matters, and once I remember saying that in a poem it was not the important words and images that one had to watch carefully, but the insignificant words like 'and' or 'of' or 'the'. We were sitting in front of a painting of an asphodel flower, translucently white against the mountains of Mykenai; and Winifred got up and laid a finger on a minute spot of white paint, almost imperceptible; at once the painting became lifeless and out of balance. She knew all about those magical touches, put in or omitted with sure judgement. Sureness she regarded as the cardinal virtue of a painting, and talked of so many paintings which were, as she said, 'dense with doubt'."

Kathleen Raine, 'The Unregarded Happy Texture of Life', 1984

White Saxifrage (Wild Lilies, Greece), 1966
Watercolour on paper, 340 x 560 mm
Kettle's Yard

*"The sunshine is very wonderful and the colour of
everything is marvellous …. The sea is emerald
near land and then aquamarine, so transparent you
can see golden gleaming transparencies to the very
depths, possibly buried sunken treasure (probably
tins). Out in the open it is the darkest blue you can
imagine, the Greeks called it the 'wine-dark' sea.
But the hills which look brown bare from the bus,
when you tread on them, are wild flowers, perfume
of honey and thyme, like a carpet – every kind
and colour of flowers and all wonderful shapes,
clear and definite like everything in Greece – blue
harebells and pink wild gladioli like lillies and the
starry asphodels and on the red earth companies
of pink pale convolvulous – pentagons looking up
to the azure of the sky – all leaves grey and downy.
I never thought of such flowers or could imagine
them in their wild profusion – campanulas like
starfish on the rocks, mauve marigolds and golden
ones – and here the mountains a yellow, lemon haze
of a tall bush like a golden glowing archangel."*

*Winifred Nicholson, letter to son Jake,
Delphi, Greece, 1 May 1961*

"Yesterday I was aware of the gulf of mist between me and the great hills. I was also aware of dusky brown versus slaty green-grey, and of some concrete objects nearby. I had no idea how I was going to amalgamate these things, but the room was quiet and before I had time to think a picture had been painted."

Winifred Nicholson, letter to Andy Christian, a young artist who came to live in Cumbria in the late 1970s

Winter, Banks Head, early 1970s
Oil on canvas, 603 x 751 mm
Kettle's Yard

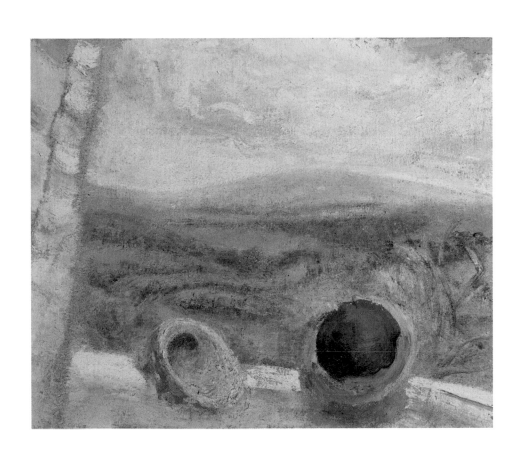

Winifred Nicholson in her own words

Liberation of Colour
Blinks
I Like To Have A Picture In My Room

Nicholson originally selected works by eight other artists to reproduce alongside her essay 'Liberation of Colour'.

They were: Christopher Wood, The Plage, Hotel Ty-Mad, Tréboul; Joan Miró, Painting – Red; Graham Sutherland, Part of a Row of Solicitors' Offices, Swansea – Orange; Van Gogh, Sunflowers – Yellow; Mondrian, Composition with Red, Blue, Yellow – Green; El Greco, Toledo in a Storm – Blue; Duccio, The Annunciation – Indigo; Marcoussis, Painting – Violet.

Here, instead of the original reproductions, seven of Nicholson's own works illustrate her ideas about colour. Each one represents her use of a different colour of the rainbow.

RED	ORANGE	YELLOW	GREEN	BLUE	INDIGO	VIOLET
clay	mud	dust	earth	shadow	slate	lead
terracotta	dun	putty	khaki	mist	pewter	prune
brick	fawn	beige	faded oak leaf	sea grey	steel	mulberry
roan	bistre	hay	sage	air force blue	blue grey	vieux rose
rust	ochre	straw	willow	fell blue	knife blue	musk rose
coral	sand	amber	crab apple	turquoise	royal	wine
ruby	flame	topaz	emerald	azure	sapphire	amethyst
RED	**ORANGE**	**YELLOW**	**GREEN**	**BLUE**	**INDIGO**	**VIOLET**
sugar pink	alabaster	sulphur	duck's egg	baby ribbon blue	ice blue	pale lilac
scarlet	apricot	lemon	pea green	sky	french blue	lavender
vermilion	fire	canary	grass green	forget-me-not	hyacinth	heliotrope
tomato	fox	brass	cabbage	larkspur	ultramarine	purple
dragon's blood	copper	daffodil	forest green	lapis-lazuli	electric blue	maroon
mahogany	tobacco	mustard	laurel	horizon	midnight	damson
RAVEN	**BLACK COFFEE**	**TIGER SKIN**	**BLACK VELVET**	**ZENITH**	**PITCH**	**CHOCOLATE**

LIBERATION OF COLOUR

What does the man who is not an artist want to know about colour? He likes colour, likes it bright when he is cheerful, sober for work in his office, and new when it is a fresh variety of sweet pea. He knows all about colour and what he likes, and what he dislikes. Music – that is different – he can hum 'God Save the King' and recognize 'The Marseillaise' – if he can't, he leaves music to the musicians.

Yet there is a Music of Colour – an art of colour which is to artists as scientific as the Theory of Musical Harmony. It is so new that few people, except those who are creating it, are aware that it exists. It is abstract and related to no recognizable objects – it is universal as a medium and powerful for the expression of thought and emotion. It is dynamic in that there is a far-reaching future ahead of it – a future of unexplored possibilities. Any reader who wants to know more of it, read on. Those who prefer to use their eyes and trust their eyes alone (and are they not the wisest?) turn to the pictures, look at them, and read no further. But for those readers who like words, read on – follow me.

To begin with there are no words for colours, only a few flower names, a few jewel names, that is all, and quite inadequate to convey the myriad shades that our eyes perceive each moment. For the colours you must use your inward eye as you read these words in black print, as I call up for you the living, glowing, vibrating tones of the Rainbow Prism that are our medium. I can give you also the key to the structure on which we are working. A structure as scientific, we think, as the octave in music or the ladder of numbers of the number table.

I have set this key out in the diagram and this is how to read it. In the centre column, reading across, you will read the seven names of the colours of the

COLOUR CHART, 1944
In 1944, World Review commissioned Nicholson to write a new article about colour; wartime printing restrictions permitted the use of only three colours. Winifred invented words to substitute for the colours she could not print. Under each rainbow colour there are seven degrees of depth, while above there are another seven degrees that she explains "rise from the highest transparency or shade of each hue to its neutralisation."

rainbow. Substitute in your mind's eye their bright hues for the written words. Now these colours are to many people, may be to you, isolated phenomena, connected with known objects. Green, that's for grass; red, that's for letter boxes, etc. If one speaks of the rainbow sequence, you have to say a childish rhyme to remember the order in which the colours run – 'Richard Of York Gains Battles In Vain'. If that is your conception of colour, you must change your notions, and accept colours in their relation to one another, each in its own place as part of white light. As this snow-white light is shattered they appear one after the other as a river sequence. Each colour takes it place, and merges into its neighbour, just as each note merges into the next note in the river of sound from bass to treble. Musicians have made halts or stations along this river of sound, and called these halts notes – the notes of the scale. Just in the same way artists have made halts in the river of light and called these halts Red, Orange, Yellow, Green, Blue, Indigo, Violet. There are seven of them just as there are seven notes in the musical scale, and this is not mere coincidence, but a fundamental of the Law of Proportion.

To go back to the diagram. You will see that colour has seven halts below indicating seven degrees of depth or density, descending from the light tones of each particular colour to its darkest hue. Above each rainbow colour you will see seven more names, these rise from the highest transparency or shade of each hue to its neutralization.

These scales are the chart on which colour artists build the conceptions of their painting. They play their melodies and their harmonies to and fro, and up and down on such a chart, very much as the composer uses the keyboard of the piano or a mathematician uses the number table in the science of calculation.

Each colour is unique, but no colour can stand alone. To get the full value of its unique colour it must have other hues by it's side, not for mere contrast, as black, say, contrasts with white, or square with circle, but prismatically to break up the rays of colour, as a shuttlecock is tossed, to and from the waves of light. Thus all the most brilliant things of nature are composed of tiny facets or mirrors which reflect and re-reflect each other – kingfisher's breast, jay's feather, butterfly's wing, fish's scales, flower petals in all their transparency – each may appear one hue, but in reality under a microscope are made up of many varied hues in true harmony, heightening each other's brilliance. So we cull our colours here and there, up and down the scale to create the particular colour we have in mind.

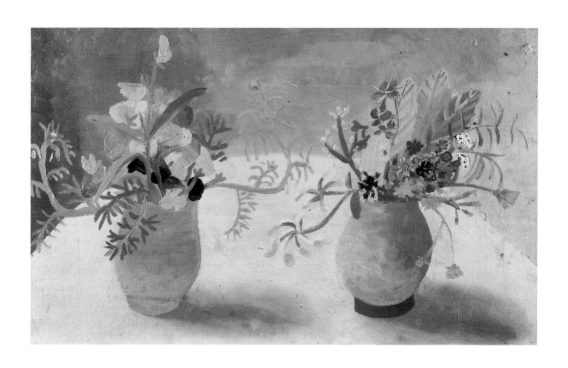

Honeysuckle and Sweetpeas, 1945
Oil on board, 440 x 711 mm
courtesy Aberdeen Art Gallery and Museums

Yesterday I set out to pick a yellow bunch to place as a lamp on my table in dull, rainy weather. I picked Iceland poppies, marigolds, yellow iris; my bunch would not tell yellow. I added sunflowers, canary pansies, buttercups, dandelions; no yellower. I added to my butter-like mass, two everlasting peas, magenta pink, and all my yellows broke into luminosity. Orange and gold and lemon and primrose each singing its note. Pleased with my success I added more sweet peas and drowned my yellow completely. Another colour emerged, not yellow. Each colour thus created by a supremacy over the other colours it finds itself among, has its own message, and this message is sufficient for the gamut of human thought, and corresponds to it; as music can correspond to it. The same science of intervals plays upon human emotion.

Red is always an assault, an insult, a danger cry, shouting Revolution! Robbery! and paradoxically, 'Homage to the King.' It is the taunting flame out of the primal volcano. It is the easiest colour to see. Man saw it first. Orange is an open colour expressing prosperity and plenty, sunbaked universe, and laughter under the sun. Yellow is the atmosphere of wisdom, reflection and calm. Green is quieter still, rest and content, the emerald ripple of wave and flow. Blue is the colour we love most, its suggestion is the lark's song, hope that soars into the stratosphere. Indigo is tragedy, like red it can stand almost alone, crying to Pluto's intense blackness, to death, and to Faith.

This conjures violet, whose magic is perceived only by keen-eyed men, but it is known by song birds and honey bees. It's wish can only be used by the great colour masters, and it is a safe indication of their mastery. It has been caught best by the Eastern painters, seeing in psychic sunlight, and it is being sought by painters such as Christopher Wood, for it calls to a colour beyond itself on the scale, a colour that our eyes cannot see, although we know that it is there by the power of its ultraviolet rays. Maybe we shall see this colour some day when we have trained our eyes more precisely. Some eyes even now, looking at a rainbow or prism, can see beyond the violet, a faint trace of fuchsia pink, the indication of the red, the first colour of the rainbow into which the colours flow in their completed cycle. For past the gap we cannot see, the violet flows back into red again. Look at the double rainbow in the stormy sky. Can your eyes see a hint of this unknown colour between the outer bright rainbow and its echo?

In music we can hear the full circle of the octave, but the colour scale differs

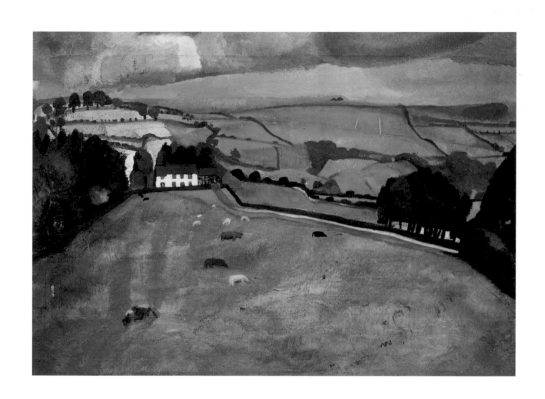

The Swaites, c.1923
Oil on canvas, 560 x 737 mm
Private Collection

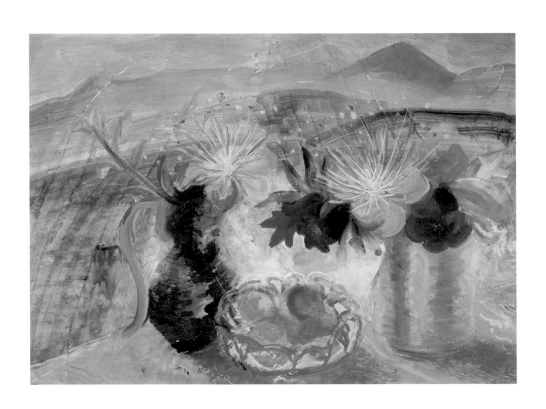

Pomegranate and Capari, 1967
Oil on canvas, 410 x 570 mm
Private Collection

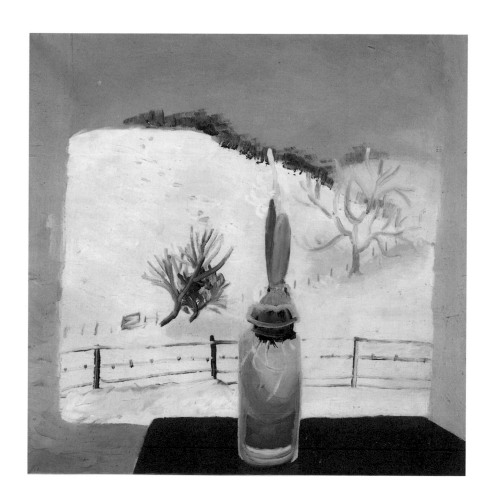

Winter Hyacinth, 1950s
Oli on canvas, 610 x 622 mm
Private Collection

in that there is this ultraviolet we cannot see, and in that lies the poignancy of violet. We have said that each colour is unique under the sun, and so it is, but the rhythm of the scale of them is not unique, it is on the contrary the universal beat of life; the sevenfold rhythmic breaks, rests, pauses, and beats on the current of sound in music corresponding to the current of time through space on the river of rainbow in light. All that we can see, all that we can feel, if our feelings are in rhythmic harmony, falls into this sevenfold rhythm, the rhythm of our universe.

It is strange that our ears detached sounds from objects so long ago, and made the art of music; while it is so recent that our eyes have detached colour from objects and made the abstract art of colour – painting. True there have always been great colourists, but the old masters used colour to denote objects. Look at Duccio's The Annunciation, how marvelously its blues tell the story of the Annunciation. It is the tale of the Annunciation that is being told, not the tale of the blueness. The angel blue – heaven's message-bringer – coming to earth blue, reception – in the world of browns and russets. Marcoussis tells me nothing of guitars, his picture is charged with the full variety of hyacinth sky contrasted with the cloistered blueness of interior blue. If I think of the great colourists, of the Italian Primitives, Vermeer, El Greco, Rubens, I think of the subjects of their pictures, I cannot forget their subjects. But I can recall the acid green of a Picasso I saw many years ago, a green as swift as the sting of a viper, while I cannot recall what form the green took, or whether the picture was representational, abstract, cubist or surrealist.

The old masters used colours as servants to express form and the colours were limited by this. I was told when I was a student that it was not possible to paint the blue of the sky. I remember reading a letter of Gauguin's which said that you could paint the sky much bluer if you painted a larger area of blue, that the blueness depended on the the proportion of the area to the other colours. I felt my eyes beginning to open. Then I read a letter of Van Gogh's which said that the blueness of the sky depended on the contrast of the blue to its complimentary colour, orange, and that colours could be made brilliant by contrasting each colour to its complimentary, red to green, orange to blue, yellow to violet. It was not only the quantity of the area of the blueness which told, but the quality of the complementary colour. So as to get his Provence sky blue he concentrated on golden-orange, cornfields, and orange-red soil. He painted in couples, in duality,

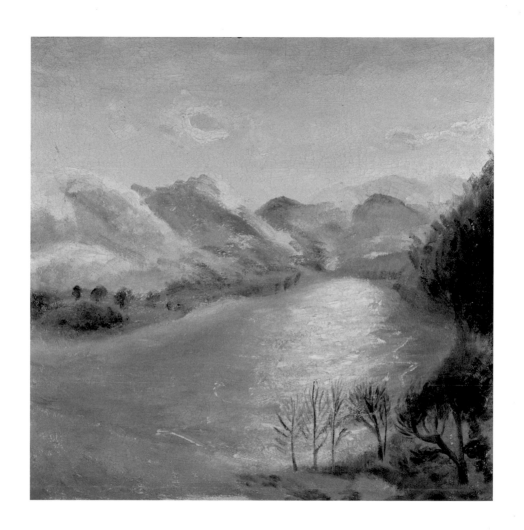

Ullswater, 1940s
Oil on canvas, 609 x 609 mm
Private Collection

and produced great masterpieces of colour, its furnace, and its fury, but he found no sanity, for colour is not a duality, and art cannot be based on two contrasting opposites, any more than life can. Duality is no solution. But he was the first of the new colour seekers who sought colour for its own sake.

Next amongst the seekers came the abstract painters. They were the men, who, having been chased out of their comfortable lodgings of Academic Representation by the camera, sought out new fields and hunting grounds where no camera could follow them. They gave up representing objects, and sought for proportion, balance, poise. They abstracted from the scale the three primary colours, red, yellow, blue, and though a Mondrian may only contain one red or one yellow and a blue, the other one or two of the three are always in mind, evoked by their very absence, if not by their presence. To these new pioneers all other colours except the three primaries were taboo. They said to me in Paris, 'You must not use green – green is not an abstract colour,' and as for using violet, that was anathema. Colour was used by then abstractly, apart from objects, but it was used to denote form, to denote the extent of their geometry. Their form and geometry were not used to denote colour as an end in itself. That remains to be done, but they did liberate colour from objects and colour as a living art sprang out, and artists realised its potentialities.

See how a Mondrian expresses the open-hearted sunlight of the brave new thought – basing it's beauty on reality and proportion. Discarding the old mystic beauty of the past, where the great visionaries like El Greco glimpsed with ecstatic eyes the dread and awesome unseen – Mondrian's gaze is quiet and confident. He does not blink. The Old Masters nailed colour, like a carpet, tight down over forms. The abstract thought released it, and its inherent power for expression became apparent. The full power of that art is still to be made visible, and the colour artists of today are working along these tones, each in his or her own vision. Matisse still works representationally, but in full chromatic scale. He uses objects to denote colours. I should think of a pink Matisse or a jade Matisse, not of a girl or a basket of fruit. Kandinsky and Miró have given up recognisable objects and use their colour free as experiment. Matthew Smith and Graham Sutherland explore transparent intensities, Frances Hodgkins the dusky, honeyed sequences, and Paul Nash the pastel scale that closely relates itself to line. Ben Nicholson touches the duns and greys and oatmeals, the mid-tones of the neutral scales.

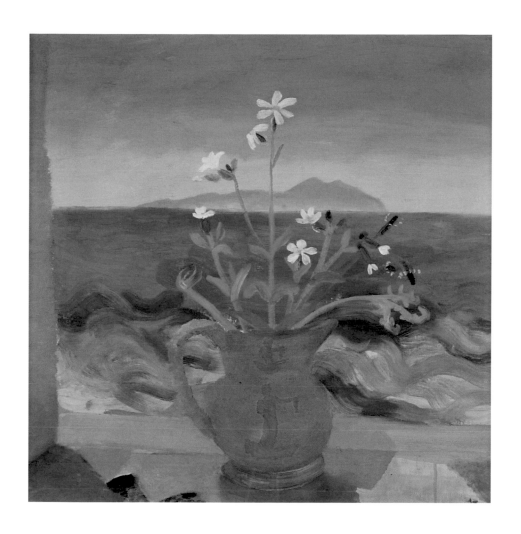

White Campion, 1940s
Oil on canvas, 628 x 629 mm
Private Collection

The present generation is not working in duality nor in triplicate, but in the sevenfold harmony of the rainbow scale, and as yet they have only ventured a little way along the road to the use of the full vitality of colour. But the way is open. Colour is free to use. You can paint 'Bluer Than The Sky'. Blueness is your aim, the sky falls below. Use the scales travelling from red to violet and the simultaneous ones from brilliance to neutral and thence to dusk. Use their sevenfold brilliance, their sevenfold depths, their sevenfold rhythm in space as geometry, not in time as in music. There is unlimited scope here. The colour will call shapes, forms and masses, recognisable if you wish, abstract if you prefer. Think in terms of intervals – wide intervals for clarion calls – red to green or vermillion to dun, close intervals for lullaby music – sea-blue to sea-green, or pearl to opal. Conjure for yourself such a picture, you will find it sheer delight, and within the range and possibility of anyone without training at an art school. Art schools teach one how to copy nature, but the joy of colour is inborn within each one of us from the child with its silver scarlet toy to the old man in his rose garden.

There is a great deal waiting to be painted, and many roads to voyage. I will leave it to you to paint new colour pictures for yourself. I hope I have obliterated for you for ever the old conception that colour must be a slave to form and must be tacked down on to objects. I hope I have shown you that colour is the vital power out of which forms, objects, images, thoughts themselves, can be created.

I have built for you the scaffolding of the artist's science upon which the new colour art is being built everywhere, even in the fiery crucible of war, because colour is as much a need for man as freedom. The savage puts a parrot's feather in his hair, the modern man paints a colour harmony, and because he is a free man of unlimited possibilities he needs a free art whose range is neither limited nor hampered in scope and yet one that meets his needs as scientifically true. He wants no nightmare nor dream fancy. Such art is search, and he wants nourishment. Nourishment of Truth, and art that answers his own inward rhythm. Such rhythm as he knows to be the rhythm of space – the heart beat of the universe.

First published (as Winifred Dacre) in 'World Review', December 1944.

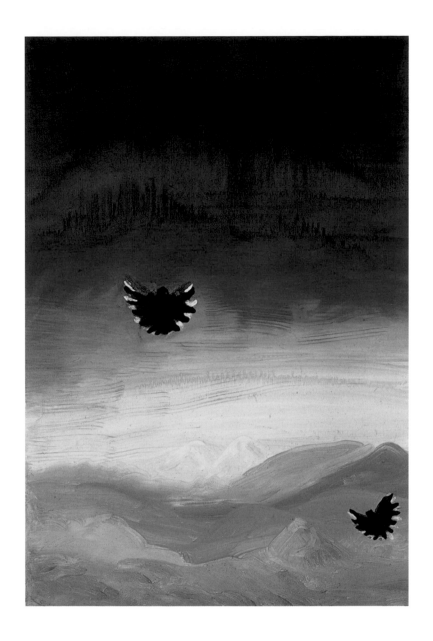

Moth Flight over the Peloponnese, 1960s
Oil on canvas 762 x 508 mm
Private Collection, on loan to Middlesbrough Institute of Modern Art

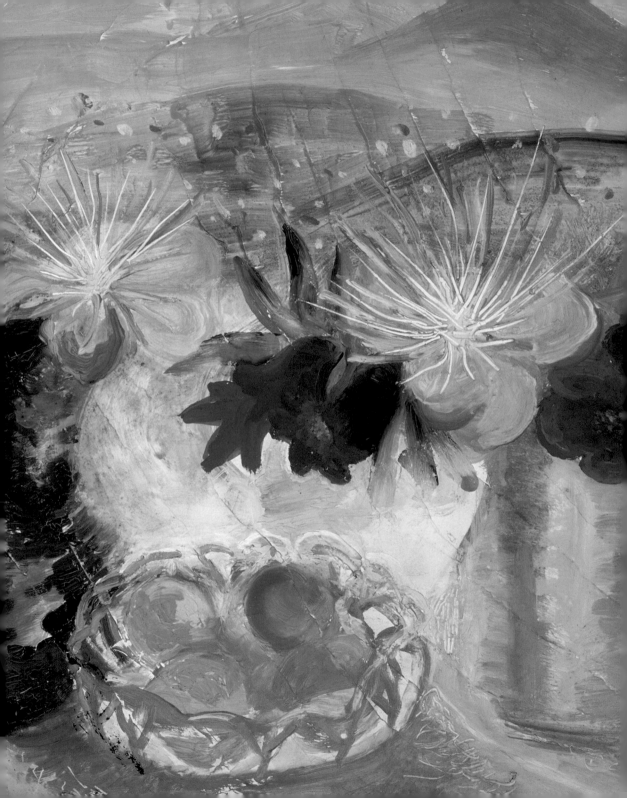

"You never circumscribe within the prison of a square bed even the tamest of flowers. They struggle, they sprawl – and if curtailed, they invite the worst weeds to come and join in the fray with them. They know more geometry than Pythagoras – and all sunflowers practice mathematical law in the spiral arrangement of their seeds. For resolving the ultimate of the universe is not all that they can tell – listen, they will show how to turn light into rainbows. They know even better than Bridget Riley. What would we do for Rose without roses? for violet, for cyclamen, for primrose, without their flowers? Flower hues change and glow and fade and are gone dead like dead leaves, gone but everlasting like the blossoms that Persephone gathered in spite of Pluto, black king of the underworld. High, low, far away, near at hand – what more fundamental opposites can be found – 'Tis my faith that every flower enjoys the air it breathes' – of course it does, for what greater enjoyment than to turn common air into perfume, light into rainbows and the irreconcilable opposites into neighbourliness of brush strokes."

Winifred Nicholson, 'The Flower's Response', 1969

Winifred Nicholson, Lugano 1922

BLINKS

When I was at art school perched on a high stool with a pigtail down my back, I was painting a shell, its mother-of-pearl captivating me – the principal of the art school, Byam Shaw, came up behind me and said, 'Oh Roberts', that was my maiden name, 'what colours you are seeing today.' The voice was disapproving. I was seeing colours in the iridescence that he did not see – and I have been seeing them ever since, or attempting to, because colours hide, they will only show themselves under the right conditions, and only to certain eyes at certain times.

As Bridget Riley has said: 'I take something – a colour, say yellow – merely a name, an inert motion – but if you put yellow with other colours in different proportions and positions, it starts to show a certain potential. It may appear lighter or darker, expand, flow into other colours, changing them. It could glow or recede and so on, and none of this behaviour you would know until you try. So right at the beginning I think – well, just see what yellow can do.' Such words are near to my inner eyes. I wrote about 'unknown colour' in an article in Circle, a book written in 1937 by the constructive artists Naum Gabo, Ben Nicholson, Leslie Martin and others of that time of vision and clarity.

As a child, and ever since, I have painted rainbows – the mathematics of colour, their sequence as true in painting as in music or the multiplication table – their appearing and disappearing as unreal as myth or fairy tale. Who can find the pot of gold at the rainbow's foot, where it touches the earth? Who can see the colour at either end of the rainbow beyond ultraviolet, before infra-red? Some people can, some people can't. Goethe called it 'peach colour'. What a name for anything so magic – except that peaches are not the colour that we are speaking of, and so it is as good a word as any of those others that we use for colours – those sensations that are indescribable in words. We speak of them as canaries, as lemons, as sunflowers, if we are trying to evoke yellow. But where does it go when the crimson flashlight blinds it, or the red car I drive comes into the electric illumination of Carlisle and my car becomes neutral dun?

Flowers and jewels are the only things that express colour fairly constantly. That is why I like them, especially flowers, for flowers know how to accord their

flower colour to the colour of their foliage. How do they know? I suppose the same knowledge that tells them that bees like scent – and scent means honey. How do they know those things without brain cells? They are as mysterious to us as the rainbow itself. How do they know when we like them so as to respond to our liking? Even the rainbow cannot do that. I can attract a tendril towards me, but I have never been able to call down a rainbow to my hand. Or is that what a halo is? 'Whiter than any fuller can white them.'

Be that as it may, what I have tried to do is paint pictures that can call down colour, so that a picture can be a lamp in one's home, not merely a window. A window is what landscape painters build into the density of the walls of those rectangles with which we surround ourselves and call our homes. The density of our vision of light is what I would like to pierce. Have I done it at all in any small way?

The first of my pictures was painted when I was a girl before the First World War, and last – well, yesterday; and I will try to do a better one tomorrow. There are so many colours that have not yet been seen. The tyranny of forms and recognised forms – can we not let our eyes free to see, to behold, what has not yet been seen of the spiral river of light?

Perhaps only with a blink or two at a time, out of the dimness into focus. These are the blinks I needed – everyone will have their own. It takes several blinks in the dark to see colour.

The first blink was when Byam Shaw told me that the colour the Pre-Raphaelites used had not held purple and cruel green because they had not seen colour as chiaroscuro – the photographer has taught us that light and shade define the space where things stand – so does colour.

Then I went to India, and noticed how eastern art uses lilac to create sunlight. After I married my eyes were opened by the Post-Impressionists. The third blink was the remark Gauguin made to Van Gogh when his friend wrote to him to ask how to make blue as blue as the Mediterranean sky. Gauguin wrote back: 'A large space of blue is bluer than a small space.'

The fourth blink was from Van Gogh, when I realized how he used the complimentary colours in contrast – red against green, blue against yellow; the duality of cold and hot which leads to madness, as Van Gogh himself found out.

And the fifth blink was when Mondrian said to me: 'Red, Yellow, Blue – these

three are pure. Purple, Orange, Green are impure, not abstract colours.'

And sixth, I said to myself: 'Why? Why halt the river of light at three stations and not at seven? The sevenfold rhythm of the scale of music, and maybe of the universe – so work with seven colours in mind, either visible or invisible, evoked by their absence, and so discover the colours of delight.'

I would like to thank all those people who have helped to open my eyes, all the people who have brought those pictures and taught me by buying them, and to thank all those members of my family who have helped, each in their own way – my grandfather George Howard, friend of the Pre-Raphaelites, of William Morris and Burne-Jones, with whom we walked hand in hand in the glens of fancy – Ben Nicholson with his eyes of genius, that see reality – our daughter Kate who understands how colours make movement – a grandson who will one day make blackness into a colour. Who else? Many others. But most of all to the wild flowers of Cumberland, of Lugano, of Mycenae, who have blossomed before my eyes and inspired me, whether they knew it or whether they did not.

First published in 'Winifred Nicholson: Paintings 1900-1978,'
Third Eye Centre, Glasgow, 1979.

Winifred Nicholson with painting materials
and Mungo the dog at Boothby, 1940s

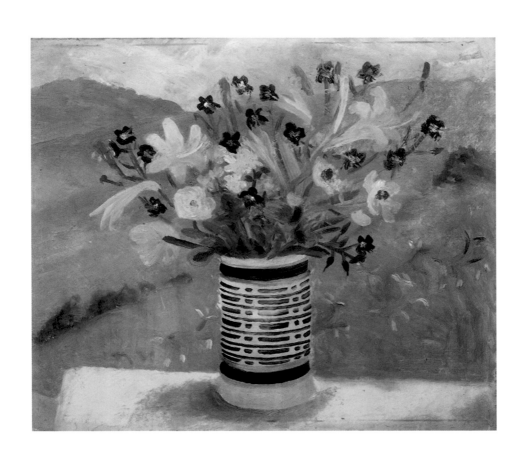

Dusky Cranesbill II, 1947
Oil on board, 1016 x 1232 mm
Private Collection

"Come and see me if you ever pass this way – I dig in the earth now till the war is over – I have seven very beautiful goats like deer with soft yellow eyes – and springing bodies – and I paint a lot and am improving I think and I hope. Country and earth and being under the sky are good for my kind of painting and working hard at other things and not being able to paint when one wants to, that's a great help too ... please give my love to Helen and to yourself – and forgive haste, I must go out and milk in the frosty moonlight!"

Winifred Nicholson, letter to Jim Ede, 1944/5

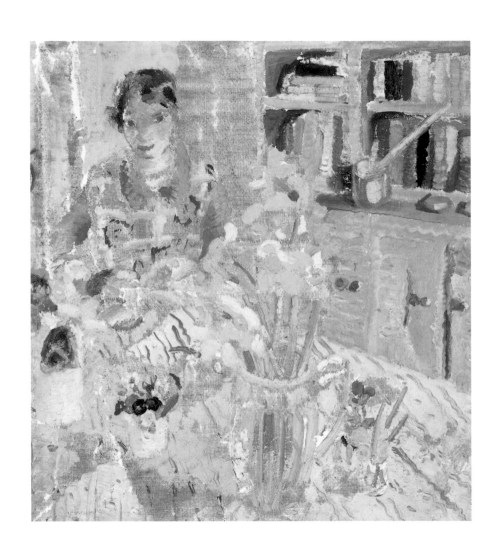

Amy in the Kitchen at Banks Head, 1928
Oil on canvas, 600 x 555 mm
Private Collection

I LIKE TO HAVE A PICTURE IN MY ROOM

I like to have a picture in my room. Why? Without one, my room feels bare however much furniture I may have; and I will tell you the part that a true picture plays, and that nothing else can play, in my room.

Pictures have played many roles. They have been altar-pieces, fetishes, idols, the courtly decorations of palaces, historical records, vain fancies, and vain fables. My dwelling room has too much going on in it for such extravagant luxuries. In the morning it is a sanctuary, in the daytime a factory, in the evening a place of festivity, and through the night a place of rest. I want a window in it, I want a telephone, a radio and a television set. All these are contacts and doors into the the outer world. But besides these, and more than all these, I want a focal point, something alive and silent. A bunch of flowers on the window sill? Yes, but they will wither. A cat curled up on the hearth? Yes, but it will go away and prowl upon the rooftops.

A picture will always be there. It will make no sound. It will not expect me to look at it while I am tapping at the typewriter, while I am cleaning the floor with the vacuum cleaner. It will wait. It will always be there. If it is a true picture I shall never grow tired of it. It will have the quality of tirelessness. I shall see someting fresh in it when I glance at it tomorrow. However familiar I have grown with it, I shall not come to the end of its friendship. It does not matter in what style it is painted. When I was a child I had a reproduction of a Dutch picture – a girl in a red jacket, reading a book in a shaded interior. I watched her read for long peaceful hours.

I now have a Mondrian on my wall – merely a contrast of horizontal against vertical lines crossing white spaces, and one poised yellow square. I have known busy politicians who cared nothing for art, come and write their speeches in the room where the Mondrian lives. That small canvas expresses the still order behind the turmoil.

For that is the quality that the picture for my room must have. In the ebb and flow of the outer world, I must have a place where the harmony of space is giving its verdict. I like harmony to be expressed in colour. For colour is one of the surest

means of expressing joy – the joy that resides in a happy home. If the colours be welded scientifically, they can glow – even make luminosity in the even light of an interior; and added to this light my picture must have recesses within itself, a flower bud or a distinct prospect, expressing the secret within all that is true. For it must certainly be a picture of truth, not photographic nor realistic, the surfaces of appearances – but measure and rhythm and scale that are its inner essence.

So the picture for today's dwelling-house must be an anchor for security, must be a lamp for delight, must be a well of peace, and when it has attained all that – and we are asking much of it – we shall ask something more, we shall ask

Two photographs of the Banks Head front kitchen taken by Arthur Jackson c. 1937. In the left photograph is the Piet Mondrian that belonged to Winifred, *Composition with Double Line and Yellow*, 1932, now in the Scottish National Gallery.

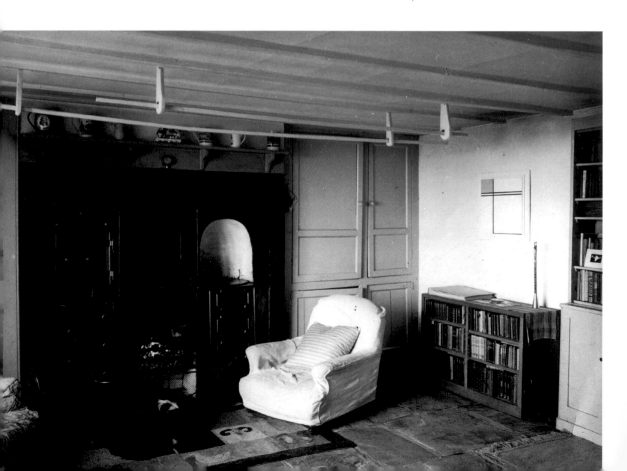

it to be a ladder — not one of those realistic ladders made of wood, that reach as far as the ceiling, but one of those upheld in places of stones, that have no limit, not even the sky; and upon which translucent thought may travel up and far away and also down and back to the home hearthfire.

That is what I want of a picture in my home. Is it the same as yours?

Published in 'Unknown Colour: Paintings, Letters, Writings by Winifred Nicholson', 1987

In the right photograph is the Piet Mondrian, *Composition with Blue and Yellow*, 1935, that belonged to Winifred's sister-in-law, Nan Roberts, now in the Hirshhorn Museum, Washington. Also visible are Winifred's *Abstract* by Arthur Jackson, a work by Alfred Wallis, and a child's drawing by Kate Nicholson.

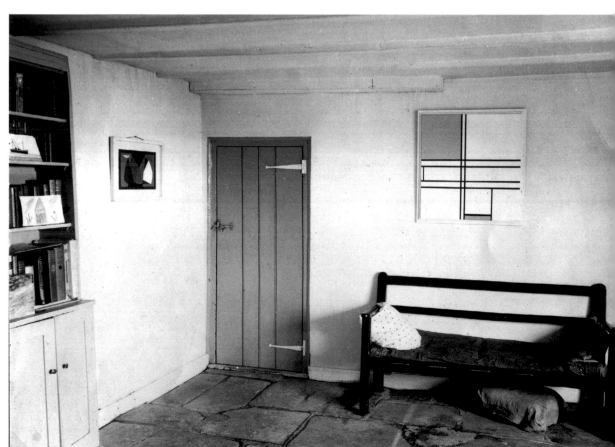

CHRONOLOGY

1893 Rosa Winifred Roberts was born on 21 December, in Oxford, to Charles Henry Roberts, Fellow of Exeter College, and Lady Cecilia Maude Roberts. Her grandfather, George Howard, 9th Earl of Carlisle, was an early influence. Winifred spent her childhood between London, Naworth Castle, Cumberland and Castle Howard, Yorkshire.

1912-19 Attended and later worked at Byam Shaw School of Art, London. Exhibited her work at the Royal Academy in 1914. In 1919 travelled to Ceylon, India and Burma with her sister and father, who had been Under-Secretary of State for India between 1914 and 1915, and was a member of the Montagu-Chelmsford Commission. She 'notice[d] how eastern art uses lilac to create sunlight'.

1920-22 Winifred met Ben Nicholson in June 1920 and they married in November. They divided their time between Villa Capriccio, on the edge of Lake Lugano in Switzerland, and Paris, London and Cumberland.

1923-26 In 1923 the Nicholsons bought Banks Head, a Cumbrian farmhouse built on the remains of a milecastle on Hadrian's wall. Both Nicholsons were elected as a member of the Seven and Five Society, and began to exhibit regularly in London. They met H.S. (Jim) Ede, then at the Tate Gallery, and his wife Helen.

1927-31 Winifred's three children were born: Jake (1927), Kate (1929) and Andrew (1931). In 1928, Winifred Nicholson's work was exhibited at the XVI Venice Biennale and Winifred and Ben Nicholson spent the summer in Cornwall where they were joined by Christopher Wood and met Alfred Wallis. The Nicholsons separated in 1931.

1932-37 Winifred spent winter on the Isle of Wight, then moved to Paris with her children in Autumn of 1932. Paris in the 1920s and 1930s were 'years of inspiration – fizzing like a soda water bottle', she later recalled. Here she met Piet Mondrian, Jean Hélion, Naum Gabo, Alberto Giacometti, Constantin Brâncuși,

Cesar Domela, Alexander Calder, Wassily Kandinsky, Jean Arp and Sophie Taeuber-Arp. She exhibited again at the XIX Venice Biennale in 1934. Her essay 'Unknown Colour' was published in *Circle: International Survey of Constructive Art* in 1937.

1938-49 Accompanied by Mondrian, Winifred returned from Paris in 1938. During the war years she farmed goats and bees and ran a small school in Cumberland. Despite this relative isolation, her article 'Liberation of Colour' and colour chart were published in *World Review* (Dec 1944). In 1948, Winifred met the poet Kathleen Raine and had a major solo exhibition at Tullie House, Carlisle.

1950-69 Winifred travelled extensively to Ireland, France, Italy, Puerto Rico, Tunisia and Morocco but the Scottish Isles and Greece were favourite destinations. She often made painting trips accompanied by her children (particularly Kate) and Kathleen Raine.

1970-80 In 1972, Jim Ede organised Winifred's first solo exhibition in the new gallery at Kettle's Yard. From the mid-70s, Winifred began to use prisms in her continuing search for a colour somewhere between violet and red. In 1975, two abstract works entered the Tate collection. Third Eye Centre (Glasgow) organised a touring retrospective in 1979.

1981 Winifred died on 5 March at Banks Head.

Major touring exhibitions of her work have subsequently been organised by the Tate Gallery in 1987, Kettle's Yard in 2001, the Scottish National Gallery of Modern Art in 2003, Abbot Hall Art Gallery in 2016 and Middlesbrough Institute of Modern Art in 2016.

BIBLIOGRAPHY

Nicholson, Winifred, (as Winifred Dacre), 'Unknown Colour' in *Circle: International Survey of Constructive Art*, eds Naum Gabo, Leslie Martin and Ben Nicholson, London: Faber and Faber, 1937 (1971), pp.57-61.

Nicholson, Winifred, (as Winifred Dacre), 'Liberation of Colour' in *World Review*, December 1944, pp.29-40.

Nicholson, Winifred, 'I Like To Have a Picture In My Room' in *Unknown Colour: Paintings, Letters, Writings by Winifred Nicholson*, London: Faber and Faber, 1987.

An Unknown Aspect of Winifred Nicholson: Abstract Paintings, 1920-1930, exhibition catalogue, London: Crane Kalman Gallery, 1975.

Winifred Nicholson Flower Tales, Cumbria: LYC Gallery, 1976.

Winifred Nicholson; Paintings 1900-1978, Glasgow: Third Eye Centre, 1979.

Ede, H.S. (Jim), *A Way of Life,* Cambridge: Cambridge University Press, 1984. Later editions published by Kettle's Yard, University of Cambridge, 1996 & 2007.

Nicholson, Andrew (ed.), *Unknown Colour: Paintings, Letters, Writings by Winifred Nicholson*, London: Faber and Faber, 1987.

Collins, Judith, *Winifred Nicholson*, London: Tate Gallery, 1987.

Baddeley, Oriana, Judith Collins and Teresa Grimes, *Five Women Painters*, Oxford: Lennard Publishing, 1989.

Collins, Judith (ed.), *A Sense of Place: Banks Head, Cumbria*, Kendal: Abbot Hall Art Gallery, 1991.

Gale, Matthew (ed.), *Kettle's Yard and its Artists*, Cambridge: Kettle's Yard, University of Cambridge, 1995.

Influence and Originality: Ivon Hitchins, Frances Hodgkins, Winifred Nicholson, Landscapes c1920 to c1950, Nottingham: Djanogly Art Gallery, 1996.

Blackwood, Jon, *Winifred Nicholson*, Cambridge: Kettle's Yard, University of Cambridge, 2001.

Winifred Nicholson, Unseen Works on Paper, London: Crane Kalman Gallery, 2002.

Strang, Alice, *Winifred Nicholson in Scotland*, Edinburgh: National Galleries of Scotland, 2003.

Winifred Nicholson: A Cumbrian Perspective, Cockermouth: Castlegate House Gallery, 2005.

Andreae, Christopher, *Winifred Nicholson*. Farnham: Lund Humphries, 2009.

Nicholson, Jovan, *Art and Life: Ben Nicholson, Winifred Nicholson, Christopher Wood, Alfred Wallis, William Staite Murray, 1920-1931*, London: Philip Wilson Publishers, 2013.

Nicholson, Jovan, *Winifred Nicholson in Cumberland*, Kendal: Abbot Hall Art Gallery, 2016.

Nicholson, Jovan, *Winifred Nicholson: Liberation of Colour*, London: Philip Wilson Publishers, 2016.

www.winifrednicholson.com

WINIFRED NICHOLSON

ISBN 978 1 904561 41 5

Revised edition © Kettle's Yard,
the Trustees of Winifred Nicholson
and the authors, 2022

Published by Kettle's Yard,
University of Cambridge
Edited by Elizabeth Fisher
Designed by Paul Allitt
Printed in the UK by Biddles Books
In an edition of 2000 copies

Original edition published to
accompany the exhibition
Winifred Nicholson: Music of Colour
28 September - 21 December 2012
Kettle's Yard,
University of Cambridge

Curated by Elizabeth Fisher
Assisted by Guy Haywood, Sarah
Campbell and Rosie O'Donovan.

With thanks to
The Trustees of Winifred Nicholson,
Jonathan Hepworth, and Robin Light
of the Crane Kalman Gallery.

Kettle's Yard
Castle Street, Cambridge CB3 0AQ
United Kingdom
+44(0)1223 748100
www.kettlesyard.co.uk

Director: Andrew Nairne

SUPPORTING KETTLE'S YARD

Kettle's Yard relies on the generosity
of supporters to care for the collection
and historic buildings, and enable
us to deliver a full programme of
activities, from exhibitions, education
activities and music to publications and
research. All gifts, large and small, help
to safeguard the collection for future
generations, and enable others to enjoy
Kettle's Yard now and in the future.

There are a variety of ways in which
you can help support Kettle's Yard
and also benefit as a UK or US taxpayer.
For more information please visit
www.kettlesyard.co.uk/supporters

KETTLE'S YARD

UNIVERSITY OF CAMBRIDGE
MUSEUMS
& BOTANIC GARDEN

Supported using public funding by
ARTS COUNCIL
ENGLAND

Research
England